IN THE REALM OF THE LOTUS

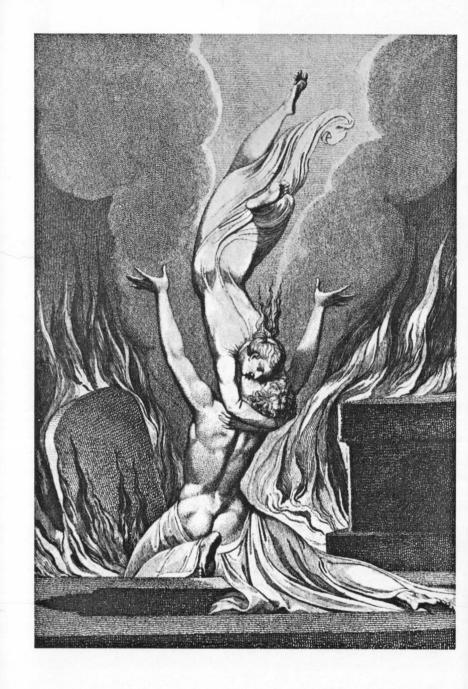

SANGHARAKSHITA IN CONVERSATION WITH J.O. MALLANDER

IN THE REALM OF THE LOTUS

A CONVERSATION ABOUT ART, BEAUTY AND THE SPIRITUAL LIFE

WINDHORSE PUBLICATIONS

Published by Windhorse Publications
Unit 1-316 The Custard Factory, Gibb Street, Birmingham, B9 4AA

© Sangharakshita and Mandart Production, Helsinki, 1995

Printed by The Cromwell Press,
Melksham, Wiltshire.

Design: Lisa Dedman
Illustrations: Varaprabha
Cover design: Dhammarati

The cover shows an illustration from an Islamic manuscript c.1555
 Courtesy of the Trustees of the British Museum
Frontispiece: William Blake, *The Reunion of the Soul and the Body*
 Courtesy of the Allen Library, University of Washington.
The publishers acknowledge the kind permission of J.O. Mallander and
Mandart Production for permission to edit and publish the transcript
of their film *In The Realm of the Lotus*.

British Library Cataloguing in Publication Data:
A catalogue record for this book is available from the British Library.

ISBN 0 904766 72 1

CONTENTS

MEETINGS WITH A REMARKABLE MAN

The Venerable Sangharakshita has been my friend and mentor for the last twenty years. The first time I met him—in this life at least—was when he visited Finland in 1974. I still have a strong mental image of this oddly familiar yet utterly strange figure. He looked like a beggar monk and a hippie at the same time.

After our meeting, wanting to get more deeply involved in Buddhism, I went to the local FWBO centre and learned to meditate. At that time I was immersed in the arts, writing criticism, running a gallery—trying to change as much as I could in a system I found unbearably conventional, spiritually dull, and full of inauthentic people with cowardly views. The big revelations of my early life came through the arts: pop art, minimal art, experimental poetry, films, books, and music: particularly jazz, which I found had an intense transforming power. John Cage was also a seminal force, as the Eastern world opened up to us in the West.

Over the next few years Sangharakshita came to Finland twice, and our private talks had a profound effect on me. I read whatever of his writings I could lay my hands on. In 1976 I was involved in starting *Aura*, an alternative magazine which published an interview with Sangharakshita as well as his essay on William Blake and his talk 'What Meditation Really Is'. I also reviewed *The Three*

Jewels when it appeared in Finnish. But the book that affected me most was *Peace Is a Fire*—a collection of condensed sayings, witty aphorisms, paradoxes, and tantric utterances which were very much on my wavelength.

But the man behind these writings remained a mystery to me. What his marvellous mindstream contained I could only guess; but what he revealed was enough to set me marvelling at his unique insights.

In 1978 I went on a magic journey to Padmaloka, a retreat centre in Norfolk, England. I can still remember the mood of those days: Padmaloka's old-fashioned garden, the serene shrine-room, Sangharakshita's study and books, the strange forest, the river, the pungent smell of the fields. The lotus pond was just being made, and I worked on it between meditation sessions—not very effectively. I could never be sure which roots were essential parts of the complex whole and which were weeds to be discarded.

Towards the end of the retreat I met Sangharakshita for a long interview. It turned out well, and I was happy. From Padmaloka I went to stay at the London Buddhist Centre, which was then under construction. The fervour of the people working on the project impressed me. On my last day in London I had a mystical experience. For about an hour that evening in Berkeley Square the gates of Heaven were opened to me, and I beheld the eternal endless light behind this creation.

In the eighties things changed for me. With a family, but no income, I had many problems, and felt compelled to put my spiritual life on hold. In 1986 I had a retrospective show of my art work: a death-and-rebirth experience of a kind.

Sangharakshita did not come to Finland again, but now and then I wrote him a letter or card, and sometimes I received a reply, or a new book—for example a signed copy of his poems which I still treasure. Towards the end of the eighties I visited him in London: a deeply meaningful encounter, although he did not say much. I felt a longing to interview him again. I knew he had more to say—and I had matured. I wanted to interview him on the subject I knew most intimately: the arts.

In 1991 I was in New York to see some modern art and the Tibetan Art exhibition, as well as to attend the Kalachakra ceremony. I sent Sangharakshita a card with enthusiastic greetings, asking him if I could interview him once again. When I arrived back in Finland I found a card from Sangharakshita agreeing to the interview and suggesting a date. I rushed to my producers, Pekka and Pamela Mandart, with whom I had discussed a series of documentaries on contemporary artists. To my surprise they were interested.

So I travelled to Padmaloka in May 1992 to make what was to me a historic documentary. I felt as though I was going to see Plato, or some other ancient wise man—perhaps Nagasena.... Sangharakshita was in good spirits: collected, relaxed, and ready to share his wealth of knowledge. I had a plan or leitmotif for the interview, but he changed the score right from the start, and I went along with his wishes. In the course of three days his vision unfolded before my eyes. Any subject that came up was handled with precision and elegance, and woven into the fabric of the screenplay. My job was easy; the themes just unfolded. But I also felt a little awkward about my role. We barely touched on many issues; there was so much more that I wanted to ask.

Still, I was happy with the way things went. During those days in the Padmaloka garden I could feel the wings of history and the muses, and a host of dakinis, in the air. The birds were singing; the weather was fine. Two lotuses bloomed in the pond, and a frog sat contemplating not far from the Buddha statue. The film crew rose to the occasion splendidly, especially the cameraman, Raine Kuisma, who was inspired to catch some hauntingly beautiful moments.

'Now the real work begins,' Sangharakshita said softly as we parted. How right he was! The problem was that, knowing full well the unique value of every word Sangharakshita says, I found it difficult, even painful, to leave anything out, to trim the material down to TV size.

But it was worth all the effort. On reading Sangharakshita's volume of memoirs, *Facing Mount Kanchenjunga*, and re-reading

his *Religion of Art*, I was pleased to find that many of the central issues were included in the film. When it was finally shown on Finnish television, I felt that a milestone in the spiritual history of Finland had been passed.

How *In the Realm of the Lotus* will fare in the wider media world I cannot know, but it is my hope that East and West may unite in art, and that the Enlightened ones may be seen more on television in the future!

I am very happy to see the edited transcript of this unique occasion in print. Many thanks to the Venerable Sangharakshita and all those involved.

J.O. Mallander
Helsinki
January 1995

J.O. Mallander, born 1944, has spent most of his adult life in the realm of the Arts, as an artist, writer, critic, art gallery manager, film-maker, and editor of four cultural journals. Involved in Buddhism for the last twenty-five years, he currently edits the Finnish Buddhist magazine, the Tiger's Eye.

Part One

A PASSION FOR COLOUR

OLLE MALLANDER: We know you as a Buddhist scholar, a prolific writer, a teacher with many thousands of disciples around the world—and a reformer, if I may say so. There are many different streams in your life and work which we could explore. But I would like to take up, as the subject of this interview, a particular stream in your spiritual life that has had a profound effect on the rest of your very active life. What I would like to ask you about is your experience of art and symbols and visions. To begin with, where does this stream come from?

SANGHARAKSHITA: Where it ultimately originates I don't really know, but from a more limited point of view it has its source in my childhood. When I was about eight years old I was diagnosed as having heart disease, and confined to bed—in fact, I was not allowed to move—and I stayed in bed for three years. So for three years the only thing I could do was read. At first my parents were hard pressed to keep me supplied with reading material, but then our next-door neighbour gave me a copy of a children's encyclopedia, in twelve thick volumes. And in those volumes there were a number of articles about art, with illustrations. So far as I can recollect, that was my first experience of art.

When I was reintroduced to that particular encyclopedia a few years ago, and I looked through it to see what had interested me as a child, I remembered that it was the section on ancient Egyptian art that I had found especially fascinating. As I flicked through the volumes, I also discovered a section called 'The Wise Men of the East'—the wise men being Zoroaster, Confucius, Lao-Tzu, and the Buddha. There were pictures too, including a photograph of the famous image of the Buddha at Kamakura in Japan. I think the brief account of Buddhism given in this section must have been my first contact with Buddhism as a teaching. So this children's encyclopedia gave me my first experience of art, both Eastern and Western, and also my first acquaintance with Buddhism. From when I was eight until I was ten or eleven, that encyclopedia was a very important part of my life.

Thus far, my experience of art was limited to small, reproduced images in books, and I can still vividly recollect my subsequent encounters with the real thing. When my health had improved and I had learned to walk for the second time, I started going to museums and art galleries in London, and there was one painting that caught my imagination more than any other. This was Titian's *Bacchus and Ariadne* in the National Gallery. Years later, I asked myself what it was in the picture that had made such an impression on me, and I came to the conclusion that it was simply the colour, the vivid, vibrant colour. I think that must have been what it was, because not long after that I became very interested in the art of the Pre-Raphaelites—the early Millais, Rossetti, Burne-Jones, and others—and of course in their paintings colour does play a very important part.

It was not just Western art to which I responded. I remember in particular a Persian miniature—from the Victoria and Albert Museum—which depicted the ascent of the prophet Muhammad to heaven. This was an important theme of Sufi mysticism as well as of Persian Islamic art, but it was not the theme itself which really interested me. What I think struck me about this miniature were the angel figures in it, because angel figures did become very important to me at about this time.

However, generally speaking, I was fascinated not so much by the subject-matter of a painting, nor by the design or the composition, but definitely by the colour.

OLLE MALLANDER: Consciously?

SANGHARAKSHITA: No. I was not aware of this at the time. But a little later the theme of colour re-emerged in my life too compellingly to be overlooked. In 1943 I had been conscripted and shipped off to India with the Army. After the war I stayed on, and my wanderings there eventually took me to Kalimpong, a town not far from Darjeeling, in the foothills of the eastern Himalayas, about four thousand feet above sea level.

From Kalimpong you can see Tibet, and the snows of the Himalayas. I lived in Kalimpong for fourteen years, and saw those mountains every day. The principal peak visible from Kalimpong —actually a double peak—was Mount Kanchenjunga.

OLLE MALLANDER: What does the name mean?

SANGHARAKSHITA: Kanchenjunga means 'the five treasures of the snow'. According to Tibetan legend, four of the treasures were—respectively—gold, silver, crystal, and grain; as for the fifth, some said it was books, some that it was weapons.

The snows weren't visible all the time—sometimes the tops of the mountains were veiled in cloud—but often enough they were revealed, and the colours were remarkable. At sunrise you would see the snows just glimmering in the dawn, white against the grey-blue, and then, as the sun rose, although you couldn't see the sun, the mountains would become a sort of pink, and then they would change to a fiery red, a sort of crimson, like a heap of glowing embers. Then they'd become a pure gold, and then a pure, dazzling white. By that time, if it was a clear day, the sky would be a deep, vibrant, rich blue.

OLLE MALLANDER: It sounds almost as though you did nothing but look at the mountains.

SANGHARAKSHITA: I did sometimes feel like doing nothing but look at the mountains, but of course I did many other things in Kalimpong. I studied, I meditated, I taught, and I also wrote a number of poems, some of which, admittedly, were about mountains, but even those weren't always *just* about mountains. I wrote a number of poems which were, so to speak, just poems—and these included haiku—but I used to feel very often that it is not enough just to write poems. I used to feel that a poem ought to have a message to it—even a moral—something inspiring and uplifting.

OLLE MALLANDER: I see you as an essentially solitary figure at this time, at least as far as contact with the Western world is concerned. But from the evidence of the second volume of your autobiography, *Facing Mount Kanchenjunga*, it seems that you found some kindred spirits while you were in Kalimpong.

SANGHARAKSHITA: Yes. When I had been in Kalimpong for a few months, I started up a Buddhist magazine called *Stepping-Stones*, and sent copies all over the world. Copies of it even found their way to some of the early Zen beat people, including Gary Snyder, whom I finally met up with in the USA two years ago. But one of the most important friends I made through that magazine was Lama Govinda. As we began to correspond, we found that our ideas about Buddhism were very similar. He had experience of several forms of Buddhism, and did not wish to identify himself exclusively with any one form. As for me, even though I had been ordained as a Theravadin Buddhist monk, I accepted the whole of Buddhist tradition, in all its richness. Theravada, Mahayana, Tibetan Buddhism, Zen, Shin—in principle I accepted everything.

In 1951, after we had been writing to each other for a while, Lama Govinda came to Kalimpong and spent some time with me. The friendship that then sprang up between us lasted for many

years—indeed, the last letter I received from him was written just four days before his death. During our first meetings, he and his wife, Li Gotami, told me about some of the experiences that are described in his classic account of the trip they had made a few years earlier to Tsaparang in western Tibet—*The Way of the White Clouds*.

In particular, I remember Lama Govinda was very impressed by the clarity of the atmosphere of Tibet, in which colours showed up so vividly. In fact, he devotes a whole chapter of *The Way of the White Clouds* to the subject, entitling it 'The Living Language of Colour'. In this chapter—among many other things—he says this: 'I realized the tremendous influence of colour upon the human mind. Quite apart from the aesthetic pleasure and beauty it conveyed, which I tried to capture in paintings and sketches, there was something deeper and subtler which contributed to the transformation of consciousness more perhaps than any other single factor. It is for this reason that Tibetan and in fact all Tantric meditation gives such great importance to colours.'

This is a very significant point. In Tantric visualization you usually begin by visualizing a vast expanse of blue sky, which symbolizes the Void, *shunyata*. It isn't easy to do this if you've never seen a really blue sky. In England we're much more familiar with grey clouds, but in Tibet the sky is a rich blue all the time, and colours stand out with wonderful vividness. Lama Govinda believed that this contributed to the development of Tantric Buddhist visualization: against the rich, vibrant blue background, you visualize the figure of a Buddha or Bodhisattva in brilliant, radiant, jewel-like colours.

That kind of awareness of and sensitivity to colour is reflected in Lama Govinda's own paintings, perhaps especially in his painting of a lake on the caravan route from India to Lhasa. He didn't use oil paints—he didn't particularly like oils as a medium, and they would have been cumbersome to carry about on his wanderings. Most of his work is in pastels, which he used to say could produce effects of colour impossible to achieve even with oils.

Lama Govinda's reflections led me not only to develop my own interest in colour, but also to understand why I was interested in colour in the first place. For instance, I have always taken pleasure in semi-precious stones—the sheer luminosity of their colours—and have accumulated quite a little collection of them over the years. I think it was Aldous Huxley who suggested that we value jewels not because of their monetary value but because they give us a glimpse of some higher archetypal realm. Certainly many scriptures and mystical writings, from Buddhist, Christian, and other traditions, describe higher worlds in terms of brilliant, jewel-like colours.

This reminds me of an occasion when I went to church with my grandmother. I must have been about sixteen at the time, and although I had ceased to be a Christian when I was fourteen, my grandmother liked me to go to church with her, so I used to go. One Sunday the sermon was on a verse from the book of Revelation, the Apocalypse: 'And every gate was one pearl.' What interested me about this sermon was not its Christian content but its imagery: that every gate was one pearl. This alone stuck in my mind; I don't remember anything else of the discourse.

Another person I got to know fairly well in Kalimpong was George Roerich, the elder son of the artist Nicholas Roerich, who of course had died by this time. He often spoke about his father, whom he had accompanied on his explorations in Central Asia.

Nicholas Roerich was a Buddhist devoted to the cult of Maitreya, and he wrote a lot on the subject. He claimed that he had seen in Tibet many signs that the Buddha Maitreya would soon be coming; and this was also the theme of many of his paintings. In some respects his work was similar to that of Lama Govinda, although Lama Govinda specialized in paintings of Tibetan landscapes and monasteries, whilst Roerich's scope was much broader. Roerich had, after all, played a prominent part in various artistic movements in the West. He had designed stage sets for Diaghilev in Paris. So there had been for him all sorts of connections with the Western artistic world which Lama Govinda had never enjoyed. Roerich's range of subject-matter is therefore

very much wider, and it must be said that his vision in artistic terms is also much broader. His colour sense was perhaps not so well developed as Govinda's, but he had a much more powerful dramatic sense. His work is very scattered, nowadays. A lot of it is in India, and there is a Roerich Centre in New York. I have a volume of reproductions of his paintings published fairly recently in Moscow, so it could be that there is some recent interest in his work in Russia as well.

His wife Helena still lived in Kalimpong when I was there. I didn't meet her, because she didn't meet anybody—she never left her room. I became aware of her existence, though, when I visited her son George. As I entered his room, I was conscious of a strong downward pressure, a sort of psychic pressure, coming from above, and I learned later that his mother lived upstairs. She was what they call a 'spiritual medium', that is, she received spiritual messages—which she wrote down and had published. She was the founder of a branch of the Theosophical movement called Agni Yoga, 'Yoga of Fire', about which Nicholas Roerich also wrote extensively.

There was a younger son, Svetoslav, who died recently. He too was an artist, and he married a famous Indian film star. I must say that the glamorous world of artists and film stars is not a social milieu I am at all familiar with, but in India I did know the mother of this film star, and it seems to be a feature of Indian social life that if you know one person, then you come to know all the people *they* know. It doesn't quite happen like that in England.

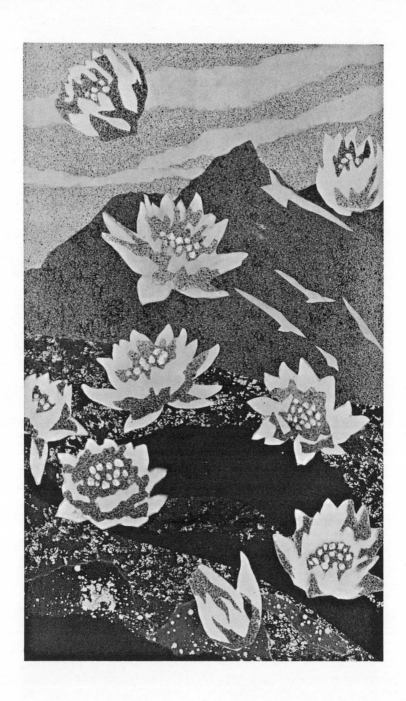

Part Two

DREAMS, VISIONS, INITIATIONS

OLLE MALLANDER: Talking about your experience of art we almost inevitably touch upon the world of dreams and visions. Can you tell us something about your dream world?

SANGHARAKSHITA: Dreams are an ineluctable part of our lives. We sleep so many hours every night, and when we sleep we cannot but dream. I have often thought that we have two parallel lives, a waking life and a dream life. We sleep for so many hours every night, and our sleep is always full of dreams, whether we remember them or not. But when we do remember, it is as if that dream world interpenetrates to some extent with the world of our waking experience, to produce another—different and enriching—level of experience. Sometimes, of course, dreams follow certain patterns; one can have the same kind of dream over and over again, over a period of many years.

When I was in India, I had a series of dreams of this kind which finally erupted into a dream experience that was something more than just a dream. For many years I used to dream of two houses—or rather, hermitages. One of these hermitages or monasteries was a public one which was open to everybody, and somewhere behind it was a very much smaller one that very few people knew about. In the dream I would usually be going from the big public

monastery to the small private one, up some secret path, sometimes on my own, and sometimes with a few other people. I had this dream every now and then for about ten or twelve years, culminating in what was not actually a dream, I think, but more a visionary experience—what one might call a 'dream-vision'.

I have sometimes thought that we can reach higher states of consciousness not just from the waking state, but also from the dream state—only, note that I say *from* the dream state: it's not that we have those experiences *in* the dream state, but that we attain them *from* the dream state, which is a rather different matter. This culminating experience of mine was of that nature, and even though it took place thirty or forty years ago, it remains vividly in my memory.

The scene seemed to be South India. After being in the big monastery for some time, I made my way, up a little path, into the mountains, and came to the second, much smaller monastery. I entered a sort of shrine-room, and in this shrine-room a man was standing. He was in early middle age, perhaps forty or forty-five. He was clad in white, a sturdy-looking figure—stocky, as we would say—with long grey hair and a long grey beard. And I knew that this was the Rishi Agastya. The Rishi Agastya, according to the Hindu tradition, was the sage who led the Aryan people down to southern India, and he is associated, in that tradition, with many esoteric teachings.

Immediately behind Agastya there was a Tibetan-style shrine—that is to say, one in the form of a sort of glass-fronted cupboard, with images and stupas and pictures behind the glass. And I was thinking 'It's strange that even though this Rishi is a Hindu figure, he is standing in front of a Tibetan Buddhist shrine, with all these Buddha images behind the glass.' But I was also conscious that in this shrine-room there was a very, very powerful atmosphere. At the same time, the Rishi was giving me various teachings—teachings which could not be put into words—and I had a strong sense of transmission, of energy being transmitted. It was as though I was being given some kind of initiation.

I don't know how much time passed, but afterwards I went out of the back door of this second hermitage to find myself in an open courtyard between two mountain peaks, one behind me and one in front. There was a sort of balustrade or parapet around the courtyard and I looked over this low wall down to the plains far below. In the distance there was a small town with factory chimneys. Later, when I woke up, I had a strong feeling that the town was an actual place somewhere in southern India which I would be able to discover if I searched for it long enough.

So this was the visionary experience I had—not just a dream, but an experience in some other world, on some other plane of existence. This seemed to me clear enough. The real mystery was—why Agastya? Granted, the setting of the dream was appropriate: the Hindus have the same kind of belief about Agastya as some Buddhists have about the Buddha's disciple Kashyapa— that even though he supposedly died thousands of years ago, he is in truth still living secretly in some mountain hermitage. But why should this Hindu sage have taken such a central role in the dream-vision of a Buddhist?

For many years, this remained a complete mystery to me. Then, on my most recent visit to India, I discovered a clue—a possible connection. It is well-known that the language spoken in South India, Tamil, is very ancient; and it is said that the oldest extant Tamil literature is influenced by Buddhism. But there is a curious detail to this ancient cultural traffic which had, up till now, escaped my attention. I discovered that there are Hindu legends to the effect that Agastya was taught the Tamil language by the Bodhisattva Avalokiteshvara. So here perhaps was the reason for this particular Hindu sage conferring some kind of initiation on a Buddhist.

It was a few years before this encounter with Agastya that I had what I like to call my 'vision in the cave'. This really did take place in South India. It took place in a cave where Ramana Maharshi— who is probably the most famous Hindu teacher and yogi of this century—had lived for many years. In 1949 I spent six weeks at Mount Arunachala, in or near the ashram of Ramana Maharshi,

and much of that time I was staying in this cave, called the Virupaksha Cave.

Buddhist cosmology tells of four guardian kings, one for each quarter, and Virupaksha is the guardian king of the western quarter. Which is interesting in view of what happened to me in that particular cave. For there I saw a vision of Amitabha, who is the Buddha of the western quarter.

I have described this vision in the volume of my memoirs entitled *The Thousand-Petalled Lotus*: 'One night I found myself, as it were, out of the body and in the presence of Amitabha, the Buddha of Infinite Light, who presides over the western quarter of the universe. The colour of the Buddha was a deep, rich luminous red, like that of rubies, though at the same time soft and glowing, like the light of the setting sun. While his left hand rested on his lap, the fingers of his right hand held up by the stalk a single red lotus in full bloom and he sat, in the usual cross-legged posture, on an enormous red lotus that floated on the surface of the sea. To the left, immediately beneath the raised right arm of the Buddha, was the red hemisphere of the setting sun, its reflection glittering golden across the waters.'

Many years later I commissioned from one of my disciples a sort of thangka representing what I saw there in the cave. And this, of course, is how Tibetan thangkas—painted scrolls—originate. They are not just artistic productions in the ordinary Western sense. What happens is that a yogi has a vision of a Buddha or Bodhisattva or guardian deity, and then either paints a picture of it himself, or else gets an artist to paint it for him according to his precise description. Of course, other painters will copy it and then the copies are copied by other artists, and very often contact with the original visionary experience is lost. But originally thangkas derive from visionary experiences. They are a form of visionary art.

The most obvious characteristic of such visionary, archetypal experiences is the luminosity of the colour in them. This is why so much of the religious art of the world has a rich, glowing,

luminous, jewel-like quality. Tibetan thangkas, Persian minia-
tures, the mosaics of Ravenna—they all have this in common.

I myself have had just a few visionary experiences, but several
of my own teachers had a great many; and the one who had the
most of all was Kachu Rimpoche. Kachu Rimpoche was the head
lama of Pemyangtse Gompa, the oldest Nyingmapa estab-
lishment in the state of Sikkim, but he was a very free and easy
lama. Many Tibetan lamas are rather formal, even a little stiff, but
Kachu Rimpoche wasn't like that. He was very informal and
friendly, and was kind enough to take considerable interest in me.
He would come to stay from time to time, bringing along his
nephew, who afterwards remained with me as my pupil for quite
a while.

Kachu Rimpoche used to meditate every morning, and usually
he'd see some kind of vision. But what was really characteristic of
him was that he would then act on it. His visions weren't, as far
as he was concerned, just visions; they were signs of things he was
to do. I remember that one morning when we were having break-
fast, he said 'What do you think I saw in my vision this morning?'
I said 'I don't know.' 'What I saw' he said 'was a banner of victory
on the roof of your vihara. We've got to have a banner of victory
on the roof.' So straight after breakfast he went into the bazaar,
found a carpenter, and got him to make a wooden frame. Then he
went to the cloth merchant and bought different coloured silks.
And then he brought the whole lot back to the vihara, and very
quickly manufactured a huge multi-coloured banner of victory.
He put it up on the roof, and performed various ceremonies—
pujas, blessings, invocations.... So this is the kind of thing he was
always doing—he was very spontaneous, never acting from
thought or calculation, but always from his visions. He was very
much a meditating lama.

Tibetans have a great belief in astrology. When Kachu Rimpoche
came down from Tibet to take up his post at the Pemyangtse
Gompa, he had to enter the monastery on a certain date at a certain
time—all according to the astrological signs. So he camped out in
the jungle in a little tent, waiting for that time to come. He had

travelled all the way from Tibet, but he just waited out in the jungle, all on his own, meditating.

Now at that time in Kalimpong there was a Frenchwoman who was the disciple of Dhardo Rimpoche, another of my Tibetan teachers—indeed, the one with whom I had the longest and most constant association. We worked together for many years, and I received a number of initiations from him. Anyway, this Frenchwoman who was a disciple of his—in fact he had made her a nun, a *shramaneri*—was giving him a lot of trouble. She was a very difficult, quarrelsome woman, and after studying with Dhardo Rimpoche for about six months she quarrelled with him, left him, and went up to Sikkim looking for another teacher. She happened to wander through the jungle where Kachu Rimpoche was staying in his tent, and came across him quite unexpectedly. So she thought 'Oh, this is wonderful! I've found another lama,' and as she knew some Tibetan, she got talking to him. He asked her whose disciple she was, and she said she was a disciple of Dhardo Rimpoche. Then he asked her what spiritual practice she was doing, and she told him that she was doing a certain kind of meditation. Kachu Rimpoche looked at her and said 'No, you haven't been doing that meditation for six months.' And it was true. She told me herself that she had told him a lie—she hadn't done that practice for six months.

I quickly saw for myself that he could read people's thoughts. Once, when he was staying with me, an American couple came to see me and wanted to talk with him, so I acted as interpreter. After a while, though, he was answering their questions before I was able to translate. Some of the questions were quite difficult, but he knew what they were asking without my translating, and gave the answers straightaway.

He was also an artist—a painter, and an excellent caster of images. After he became head lama, I went to see him at Pemyangtse, and found him in his room sitting on the bed. Underneath the bed were the pieces of a life-sized silver image which he was in the process of casting. And what was interesting from my point of view was that this image was of

Padmasambhava, because it was Kachu Rimpoche who initiated me into the practice of Padmasambhava (along with that of Amitayus, the Buddha of Long Life). He was casting this particular image of Padmasambhava in memory of Jamyang Khyentse Rimpoche, who had died not long before. Kachu Rimpoche was a staunch follower of the Nyingmapa tradition, and a staunch disciple of Jamyang Khyentse Rimpoche, from whom I too received a number of initiations. Jamyang Khyentse was said to be the greatest Tibetan scholar of this century, a vastly learned man of great spiritual experience—and something of a visionary too.

When a lama gives the initiation of a Buddha or Bodhisattva, he is, at the same time, supposed to meditate on that Buddha or Bodhisattva and visualize him (or her). In the course of my own initiation, as Jamyang Khyentse performed the ceremony, I noticed that he was looking up, and I had the strong impression that he could actually see the various Bodhisattvas whose initiations he was giving me—Manjushri, Avalokiteshvara, Vajrapani, and Tara. He had a smile on his face as though he was recognizing them while he was performing the ceremony.

I also received initiations from Dilgo Khyentse, who died not so long ago, and from Chatrul Sangye Dorje, a remarkable lama who spent many years wandering about Tibet and meditating. He wasn't an incarnate lama—or rather I should say he *isn't*, because he is the only one of my principal teachers who is, at the age of eighty-two, still alive. I received my first Tantric initiation from him, which was that of Green Tara, so he occupies quite an important place in my spiritual life. In fact, all my teachers occupy an important place in my life; and I certainly remember them all the time. Some, perhaps, more than others, but they are at the back of my mind all the time, I could say.

Dudjom Rimpoche, another of my Tibetan teachers, once explained to me that when the lama gives the initiation of a Buddha or Bodhisattva, it's as though he is introducing you, the one to the other. He is, as it were, saying to the Bodhisattva, Tara, as it might be, 'Tara, here is my disciple so-and-so.' And then he says to the

disciple 'This is Tara.' In this way he makes the introductions; he creates a connection. To be able to do this, of course, he must first establish his own connection with Tara, or whoever the deity is. It's as though he puts himself in contact with that experience, and because he is in contact with it, he can be the means of putting you in contact with it. He can't give what he hasn't got himself. So there can't really be any such thing as a purely formal initiation. An ordinary lama who hasn't got much spiritual experience may go through the motions of the ceremony—this occurs all too frequently, I'm afraid—but in this case really not very much happens.

Usually visions are seen by one person. When they are seen by a number of people then they become something more than just visions. In the case of Lama Govinda's teacher, Tomo Geshe Rimpoche, one of the most famous visionary Tibetan lamas, it was as though his visions materialized so that they could be perceived by other people—on one famous occasion, by hundreds of other people. I heard about this incident from Tibetans in Kalimpong before I met Lama Govinda. They said that when Tomo Geshe Rimpoche was once travelling in a particular area of Tibet, the people there saw Buddhas and Bodhisattvas in the sky, and then very large, lotus-like flowers started raining down, so real that people could touch them and take them up. These strange flowers apparently survived about half an hour, before they melted away. I was told that the whole episode has been depicted in a fresco on the walls of the Dungkhar Gompa in the Chumbi Valley of southern Tibet, where the Dalai Lama stayed for a while after the Chinese invasion of Tibet.

Tomo Geshe Rimpoche is not the only person credited with this spectacular gift. I heard a strange story recently concerning the contemporary Hindu yogi, Satya Sai Baba, who is famous for materializing things. The story was related to me by some of my Western disciples who had made the trip to Kalimpong. While they were there they visited a small shrine where a Tibetan disciple of mine, called Sherab Nangwa, used to live. He died just a few years ago. He was much older than me, but he had wanted

me to ordain him, so I did. Anyway, on the altar of his shrine there was a picture of Satya Sai Baba, and the local people told my disciples that when Sherab Nangwa was living there, this photograph of Satya Sai Baba used to produce holy ashes. It apparently stopped doing this when Sherab Nangwa died.

I just don't understand these strange occurrences—which is no reason, of course, to believe that they don't happen. In Buddhist eyes they have no great spiritual value, but they do suggest that the laws of nature are more profound and complex than we usually think.

OLLE MALLANDER: The East seems to provide more fertile ground for such occurrences than the West does. Maybe, though, they do also happen in the West, only people don't know how to perceive them, or they don't pay attention.

SANGHARAKSHITA: They don't pay attention. In the West we don't perceive such things, even when they happen before our eyes, simply because we just don't pay attention. Similarly, when small children start talking about experiences before they were born, we're inclined in the West to dismiss it as just childish imagination, but in the East it would be taken seriously as recollections of a previous life.

Later on in my time in India I came to know the new Tomo Geshe Rimpoche, the reincarnation of Lama Govinda's guru. At the time of the Chinese invasion he was arrested by the Chinese, because he was supplying the Khambas with *ribus*, magic pills, to protect them. The Chinese imprisoned him, and treated him very badly. But he had been born in Sikkim, which was a protectorate of India, so the Indian government applied for him to be returned to Sikkim and the Chinese agreed, so eventually Tomo Geshe Rimpoche came to Kalimpong. We became quite good friends—I would have been about thirty-five then, and he was twenty-two or twenty-three.

He was a strange person. To begin with, he was very small. The Sikkimese, especially the Lepchas, are often small, but he was

exceptionally small and thin, and he had a very quiet voice. Despite his diminutive stature, however, people had great respect for him. He also had a sly sense of humour, and he was fond of pulling my leg. Sometimes it was difficult to know whether he was joking or not, because his sense of humour was so subtle. Although he was only in his twenties, his movements, his bearing, and his speech, were just like those of an old man. And he was very fond of little animals; he kept a number of dogs and cats and birds. This was not unusual—many incarnate lamas did the same: Dhardo Rimpoche had lots of little dogs and cats and birds as well.

I have been very fortunate in my teachers. As well as the valuable contact I had with the Tibetan lamas I have mentioned, I was fortunate enough to be able to learn from Yogi Chen, a master of Chan Buddhism. Mr Chen was a hermit who lived in a little house on the edge of the Kalimpong bazaar. He never came out. He spent most of the day meditating and saw very few people. I came to know him quite well, however, and got into the habit of visiting him once a week, on a Saturday evening. He was a mine of information about Chinese Buddhism, and all sorts of yogic practices. His spiritual experience was vast. He was also a very eccentric person. He did strange things, and he was constantly seeing visions.

My first teacher, however, was neither Tibetan nor Chinese, but Indian. This was Bhikkhu Jagdish Kashyap, who was a very learned man, a master of the Tripitaka. I studied Pali, Abhidhamma, and Logic with him in Benares in 1949 and 1950, and he it was who took me to Kalimpong, and told me to stay there and work for the good of Buddhism. He was a great scholar, but very kindly and unpretentious; I was very fortunate to be able to study with him.

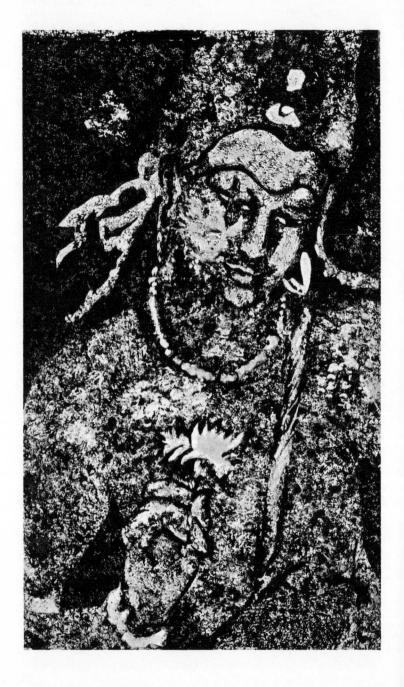

Part Three

ASPECTS OF ENLIGHTENMENT

OLLE MALLANDER: In your study, besides pictures of your teachers and friends, you have many images and thangkas of archetypal forms. Would you say something about the meaning of these symbols?

SANGHARAKSHITA: When one is initiated into the 'cult' of a Bodhisattva, especially of an archetypal Bodhisattva, one is being introduced to an image of a particular aspect of Buddhahood or Enlightenment. We may say that Enlightenment has three principal aspects: the aspect of wisdom—or insight into ultimate reality, the aspect of spiritual vigour or energy, and the aspect of compassion. These three aspects of Enlightenment are embodied in the forms of the three Bodhisattvas known to Tibetan Buddhists as the 'Three Family Protectors': Manjushri, Vajrapani, and Avalokiteshvara.

Manjushri is the embodiment of wisdom, of insight into reality. His name means 'gently auspicious one', and he appears in many forms. Sometimes he appears as Manjughosha, 'gentle-voiced one', a manifestation with slightly different iconography. But the best known form of Manjushri is probably Manjushri Arapachana. Here he is depicted as a youthful warrior or prince who holds aloft the flaming sword of wisdom, with which he cuts asunder the

bonds of ignorance that prevent us from realizing Enlightenment.

Spiritual energy is embodied in the figure of Vajrapani. He is sometimes depicted in peaceful form, but the best known image of him is his wrathful manifestation, a massive dark blue figure with bulging eyes and a fierce expression, with an aura of flames, stamping to the right, and holding in his right hand a vajra, the diamond-thunderbolt, symbol of unstoppable power.

The third of these three protectors is Avalokiteshvara, sometimes called Padmapani (which means 'lotus in hand'). He is the embodiment of the compassion aspect of Enlightenment, and is popularly said to have 108 different forms (108 being a highly auspicious number in Tibetan Buddhism). The Dalai Lama, of course, is believed to be the manifestation in particular of Avalokiteshvara. The mantra of Avalokiteshvara is the famous *om mani padme hum*, which is usually translated as 'the jewel in the lotus', although it should be said that it is in the nature of a mantra that it cannot properly be translated at all.

All these various Bodhisattvas come to us as various depictions of Enlightenment, but they depict that spiritual ideal in an ideal form. In this they contrast strikingly with the depiction—particularly in Chinese Buddhist art—of Arhants, that is, men who have gained Enlightenment through following the teachings of the Buddha. The tradition is for most Bodhisattvas to appear as radiant and beautiful sixteen-year-olds, whereas Arhants are represented as being old and ugly, even deformed. So why this contrast? I gave quite a bit of thought to this question some time ago, and I came to the conclusion that Bodhisattvas represent the spiritual ideal in its perfection, as it exists in another world, on another plane, whereas Arhants represent that same ideal as embodied under the conditions of history, as limited by space and time. For time and space *are* limitations: when the ideal becomes embodied in actual life, it cannot exhibit the full perfection that it has in a higher, more ideal realm.

The depiction of Bodhisattvas in Buddhist art is meant to give us a glimpse of that ideal realm, free of the limitations of space and time, and some very exceptional works do succeed in this

endeavour. I was in Ajanta recently, and had the opportunity to examine each of the thirty caves there quite closely. As it happened there were not many visitors there that day, and the caretakers, being Buddhists, made very helpful use of lights and mirrors in order to show us the paintings. These have, of course, deteriorated badly even since they were discovered. They are going to be restored by a Japanese team soon, and the caves will be closed to the general public for several years while that is being done. But what is visible is extremely beautiful, especially the famous Padmapani figure with the blue lotus in his hand. This painting was still vivid in my memory from my first visit to the caves more than twenty-five years previously, but I was even more pleased to see it on this occasion. The expression of the face is really quite remarkable. It's compassionate and it's sad—and yet 'sad' is too strong a word, and even 'compassionate' is too strong a word. It's so much more refined and delicate than that. I don't think there is anything comparable in Western art as regards delicacy and refinement of expression except in the work of Leonardo da Vinci. The sculpture in the caves, by contrast, is very solid and—one couldn't exactly say crude—massive is the word to use, I think. In fact, 'massive' will do for the appearance of the caves generally: the columns are fat and squat, with cushion capitals.

Padmapani is an example of an archetypal Bodhisattva, a depiction of a particular facet of Enlightenment, as envisioned by a meditator in the course of his meditation. However, there are also living practitioners of Buddhism whose spiritual practice is of such a high standard that they may be thought of as living Bodhisattvas. I have mentioned that the Dalai Lama is thought of as the emanation of Avalokiteshvara, the quintessence of compassion. I myself have no doubt that I have met living Bodhisattvas, Buddhist practitioners par excellence—like, for example, my teacher Dhardo Rimpoche.

There is one figure who is regarded both as having had a human, historical existence and as being an archetypal embodiment of the qualities of Enlightenment. This is Padmasambhava, and there is a traditional account of his life, *The Life and Liberation of*

Padmasambhava, which fuses the human and the archetypal aspects of this Bodhisattva by spectacularly interweaving historical and mythical strands of biographical material. Padmasambhava was a great Indian Buddhist teacher who lived round about 800CE, at a time when Buddhism was first being introduced into Tibet. The king of Tibet had been converted to Buddhism, and had commissioned a huge monastery to be built, but the walls kept falling down, because, it was said, the local gods and spirits objected to being displaced by the new religion. Padmasambhava was invited to Tibet in order to subdue these local gods and spirits, so that the monastery could be completed.

Before going to Tibet, Padmasambhava visited many parts of India and the adjacent regions, and, according to legend, in each of the regions he visited, he assumed a particular form suited to the inclinations and temperament and spiritual needs of the people of that particular region. He assumed very many forms but, later, eight forms in particular were recognized, and these eight forms of Padmasambhava are commonly depicted in Tibetan thangkas.

The form known as Guru Padmasambhava is the one in which Padmasambhava went to Tibet. Here he is found in the robes of a Buddhist monk, and wearing the so-called 'pandit cap', signifying a master of the Buddhist scriptures. Thangkas conventionally depict snow peaks in the background, which probably represent the snows of Tibet to which he journeyed.

The *Shakyasingha* form of Padmasambhava represents him as the 'lion of the Shakyans', which is, of course, the title of the Buddha himself, Shakyamuni—the historical Buddha. The followers of Padmasambhava, the Nyingmapa sect of Tibetan Buddhism, go so far as to say that the Buddha Shakyamuni was one of the eight forms of Padmasambhava—a view which most Buddhists would not, of course, accept.

The 'esoteric' form of Padmasambhava comprises a male Buddha form and a female Buddha form locked in embrace. The male Buddha form represents compassion and the female form wisdom, so the figure as a whole represents the union, so to speak, of

compassion and wisdom within the enlightened mind of Padma-sambhava.

Next, the form of Padmasambhava known in Tibetan as 'the thoughtful coveter of the best' depicts him as a lay teacher. He is carrying a *damaru*, a little Tibetan drum, which represents the sound of the Buddha's teaching; and he also bears a bowl full of nectar, to represent the blissful experience that results from prac-tising that teaching.

There are two wrathful, demonic forms that Padmasambhava assumes. In one he is riding on a tiger and wielding the diamond or thunderbolt sceptre in order to counteract the negative in-fluence of false teachers. The other is called 'the Roaring Lion', in which form he again subdues the forces of evil.

Then there is Padmasambhava as the 'Lotus King' In this form he is sounding a *damaru* and he has a bowl with what in some depictions is shown as a moon. Here he represents a righteous ruler—that is to say, a king who rules his country in accordance with the principles of the Dharma, the Buddha's teaching.

Finally, Padmasambhava appears as a yogi. He wears just a tiger skin round the waist, and a very meagre upper garment, and he carries his characteristic staff, with the five skulls to represent the Five Wisdoms, which are, of course, sometimes personified as the Five Buddhas. The very graphic image of the skull signifies, I would suggest, insight into the ultimate nature of all existence, the Void, *shunyata*.

OLLE MALLANDER: Recently we in the West have been treated to a major exhibition of Tibetan art.

SANGHARAKSHITA: Yes. And it is certainly of more than historical interest. Many of the items are of very great artistic value as well. I personally like the thangkas with the pure red background and the figures picked out in gold. I'm told that this particular style was a characteristic of Kham Tibetan Buddhist art. The contrast of the red and gold produces a definitely visionary and non-realistic kind of impression.

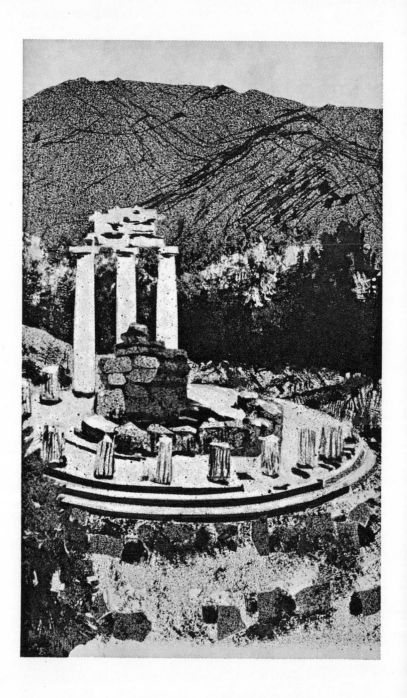

Part Four
RETURN TO WESTERN CULTURE

OLLE MALLANDER: After about twenty years I believe you returned to the West and in many ways rediscovered for yourself Western, European art.

SANGHARAKSHITA: When I came back to England in 1964, after having been away for twenty years, there were many things which were strange to me. People's way of life had changed very much; and especially I noticed that they seemed much more prosperous than before. New services and utilities had sprung up—things like supermarkets and launderettes, which had simply not existed before the war.

Of course, these were not the aspects of Western life which most interested me on my return, though their pervasive impact could not be ignored. My main concern was to establish my own connections with Western culture. So after I'd been back in England for about a year and a half, I embarked on a sort of cultural pilgrimage to continental Europe with a friend of mine who drove me around. We went through Belgium, France, and Switzerland, down to Italy and across to Greece, and I took in a lot of monuments, art galleries, churches, cathedrals, temples, and so on.

In Italy it was the brilliant colours of the mosaics of Ravenna which made the strongest impression, together with the mosaics

in St Marks—partly because I hadn't heard of them before. And the catacombs of Rome were quite a profound experience for me. However, it was in Greece that I found myself moved most deeply—by the sacred places of ancient Greece: Delphi, Epidaurus, and Olympia. And by Delphi most of all. Shortly before I left Kalimpong, I'd read Henry Miller's *The Colossus of Maroussi*, in which he gives a very inspiring description of Delphi, so I was well prepared to be inspired. And I was not disappointed. The natural beauty of the place combined exquisitely with the beauty of the archaeological remains. And I remember sitting on the hillside looking down at the ruins of the temple of Apollo and reading Euripides' *Ion*, written two-and-a-half millennia before, the action of which is set in that very place—the temple of Apollo at Delphi.

In Epidaurus, which was the great healing centre of ancient Greece, I really did feel a calm, healing influence. And in Olympia, it was, of course, the archaic sculpture I responded to. Indeed, of all the ancient sculpture I saw in Greece—and I saw a lot—I think I was more impressed by the archaic sculpture than by the works of the classical period. I hadn't really expected this, but then I hadn't really known anything about archaic Greek sculpture before.

In 1981, quite a while after the foundation of the FWBO, we started holding ordination retreats in Tuscany, at a place called Batignano, which is not too far from Siena. And that gave me the opportunity of renewing my contact with Italian medieval and Renaissance culture. I became particularly fond of Siena and Sienese art, but I also visited Florence, Rome, Naples, Venice, and Pisa.

Going round museums and art galleries I encountered certain symbols again and again. Needless to say, there were hundreds and hundreds of Madonnas and Crucifixions, but these didn't appeal to me very much. The image that did appeal to me was the figure of Saint Jerome—so much so that I wrote two essays about him. Saint Jerome was, of course, the author of what eventually became known as the *Vulgate*, the Latin translation of the Bible

used throughout medieval Christendom. And I found that there were very many paintings of Saint Jerome, including examples from some of the greatest artists, like Dürer and El Greco. Usually he was depicted either in his study, working at his translation, or in the wilderness doing penance.

Saint Jerome became an important symbol to me because he was a translator, and I thought a good deal about what being a translator means. It isn't just a question of translating from one language to another. Translation is making known something that was unknown, bringing something up from the depths, from—if you like—the unconscious, bringing it into the light of consciousness, and in that way making it generally available. I thought in this connection of the Buddhist figure Nagarjuna, who receives the teachings of the Perfection of Wisdom from a dragon princess—she comes up from the depths of the ocean and hands these scriptures to him. That was a translation, in a way, and Nagarjuna was a sort of translator. You could even say the same thing about Asanga, because translation is not just a question of bringing up from the depths, but also of bringing down from the heights. Asanga is believed to have ascended in meditation to the Tushita *devaloka*, the higher spiritual realm where Maitreya, the future Buddha, was living—and still is, according to Buddhist tradition. There he received teachings there from Maitreya, which he then brought down to earth. So he also is a translator.

OLLE MALLANDER: Another subject which is also very close to your heart, and which you also must have encountered in the art galleries of Italy, is the subject of angels.

SANGHARAKSHITA: Yes. Angels occupy quite an important place in Western religious art, especially perhaps in medieval religious art. Coming upon so many examples of this type of painting I started remembering that when I was about thirteen or fourteen I made a whole series of detailed drawings of angels. We all know in a general way what is meant by an angel. An angel is a being belonging to a higher sphere of existence—an intermediate being,

half in the realm of absolute reality and half in the ordinary, everyday world. In some ways, angels correspond—very roughly, very approximately—to Bodhisattvas in Buddhism. And angels function as messengers (the word 'angel' in Greek meant originally just 'messenger') which is perhaps why they are winged. The angel represents the messenger coming from the world of higher reality, even the world of ultimate reality, bringing a message about that higher reality to us, down here on this earth. So the angel is also a sort of translator, perhaps in a more direct way than Saint Jerome.

Angels appear in all spiritual traditions. I've mentioned the Bodhisattva as the Buddhist equivalent of the angel figure in Christianity. Angels also appear in Islamic—especially Persian— art, where they are portrayed in much the same way as in Christian art. They are, though, very colourful, often with very beautifully coloured wings, and in this respect they are like Fra Angelico's angels rather than the more sentimental type from later Western art—a type one can never quite believe in. But Fra Angelico clearly did believe in his angels. They are quite credible in imaginative terms, and notable for the beautiful peacock-like colouring of the wings.

When they appear in modern art, angels seem less likely to conform to the sentimental stereotype. In the Ateneum gallery in Helsinki, for instance, there is a painting by a Finnish artist of a 'wounded angel'. The angel's head is bandaged, and he is sitting on a stretcher being carried along by two boys. The message in this painting is clear enough. It suggests that some sort of higher faculty—maybe the imagination—has been badly damaged in our modern era. Angels also feature prominently in the work of a contemporary English artist—Cecil Collins—who depicts angels in a quite non-realistic, almost abstract way, which is at once strange and also quite evocative and meaningful. There are twentieth century literary angels as well—one thinks, for example, of the very dramatic appearance of the angel in Rilke's *Duino Elegies*.

So as regards the Western cultural and spiritual tradition, the figure or symbol of Saint Jerome and the figure or symbol of the

angel are both important to me personally. Both of them are translators, in their different ways; both of them are messengers. Both of them, in other words, bring to us spiritual riches we might not otherwise have access to.

Part Five

BEAUTY AND THE HIERARCHY OF ART

OLLE MALLANDER: *As stars, a fault of vision, as a lamp,*
A mock show, dewdrops, or a bubble,
A dream, a lightning flash, or cloud,
So should one view what is conditioned.
These words of the Buddha suggest a strong appreciation of
nature. Would you say something about the Buddhist view of
nature and your own relation to nature?

SANGHARAKSHITA: These comparisons are taken from a well-
known Buddhist text, the *Diamond Sutra*, and they are meant to
illustrate the impermanence of all conditioned things. The light-
ning flash doesn't last very long, the dewdrop doesn't last very
long, the cloud drifts by, the dream comes and goes. All these
things are evanescent, impermanent. Life is like that.

But there is something else to notice about these comparisons:
they are all beautiful. They may be illustrating impermanence, but
they also illustrate the beauty of the world. The cloud is beautiful
as it floats through the sky. The dewdrop is beautiful as it glistens
in the early morning sunlight. The lightning flash is beautiful in
its brief, awesome power. The bubble on the stream, reflecting
myriad hues—like a rainbow sometimes—is also beautiful. So to

my mind there is a twofold message in that particular verse: life is fleeting, life is transient, but life is also beautiful.

In the early Buddhist scriptures—those, that is, which can be said to reflect the historical circumstances under which the Buddha taught—there is evidence of a very great sensitivity to the natural world. The Buddha himself, as also his immediate disciples, lived close to nature. He was actually born in an orchard—his mother holding on to the branch of a tree. He gained Enlightenment at Bodh Gaya sitting underneath a tree. He died in the sal tree grove of the Mallas, stretched out between two sal trees. And of course he spent much of his time wandering from place to place, from village to village, in the open air.

So Buddhism had its origins in the open air, and this open air background to the scriptures inevitably affected the way the Dharma was taught by the Buddha and experienced by his disciples. For instance, there is a set of verses in the *Theragatha* ('Verses of the Elders'), attributed to one of the Buddha's senior disciples. In it he describes a cloud—a heavy, black, or rather, dark blue, cloud—and how a white bird flies across the dark cloud. And it seems that the beauty of this sight sends him into a sort of ecstasy.

Scholars have a tendency, perhaps, to overlook this aspect of Buddhism in their intent to present Buddhism as a *teaching*, sometimes, even, as quite a dry, methodical, analytical teaching. But if you look at the *life* of the Buddha, the life of his close companions, you see the natural world very much *there* in their lives, in their practice of the Dharma. And there is therefore a close connection, I would say, between early Buddhism and the natural environment.

OLLE MALLANDER: Also the different spiritual stages culminating in Enlightenment are very often presented in terms of natural phenomena.

SANGHARAKSHITA: Yes. The most common symbol in Christianity is the cross, even the crucifix. But the most common symbol

in Buddhism is the lotus flower. It goes right back to the time immediately after the Buddha's Enlightenment, when he was wondering whether or not he would ever be able to communicate his experience to others. He looked out over the world and saw human beings as lotus flowers growing in a pond. Some were deep down in the mud, some had just raised their petals above the water, and some were standing completely free of the water, opening their petals to the sunlight. This was the Buddha's vision of humanity. And through it he knew that human beings could grow and expand and open up to receive the sunlight of the Dharma—and that like blossoms, some individuals were more developed and mature—and therefore more receptive to the Dharma—than others.

So it does seem that the Buddha himself was not just conscious of the natural environment but felt deep sympathy with it. The Buddhist scriptures are full of references to nature spirits—spirits of the trees, spirits of the ponds, spirits of the streams, even spirits of flowers. There's a story in one of the scriptures of a monk who goes and smells a lotus flower growing in the water, and the spirit of the flower comes out and says 'Why are you stealing my scent?'—which obviously gives the monk something to think about. In future he won't thoughtlessly take from nature without asking permission in some way. He won't even think to smell a lotus flower without the flower's permission. After all, it isn't *his* scent—it's the flower's scent.

This does, perhaps, convey to us some kind of environmentalist message about the way we exploit nature. The idea that we shouldn't so much as smell a flower without seeking the flower's permission might seem a bit sentimental, but there is a philosophy underlying it which has some quite far-reaching implications for us today. And this is that there can be a sort of imaginative identification between man and nature.

OLLE MALLANDER: There is that Zen saying: 'An old pine preaches wisdom, a wild crane cries out the Truth.'

SANGHARAKSHITA: Yes. And Wordsworth says much the same thing, of course in his own way:

One impulse from a vernal wood
Can tell us more of man
Of moral evil and of good
Than all the sages can.

Unfortunately, the way it is put can make what Wordsworth says seem trite and sentimental, but it is nonetheless true. One certainly doesn't want to be sentimental about it, but if one reflects on nature, if one is in sympathy with nature, then yes, one can learn.

OLLE MALLANDER: From love of nature, it is a small step to the subject of art and poetry. Beauty is always a unifying factor. And you have made an important statement of your views on the subject in your book *The Religion of Art*.

SANGHARAKSHITA: Nowadays, of course, beauty is regarded as rather an old-fashioned idea. Many modern artists and art critics would not accept the validity of talking in terms of beauty; they have other criteria. But personally I believe that the concept of beauty is very important and valid. We are all susceptible to beauty. And one of the characteristics of appreciation of beauty is that it is quite disinterested. When you see a beautiful flower, you appreciate it just for its beauty. You don't want to *do* anything with it. You don't want to own it, possess it, take it to pieces, analyse it. You just want to contemplate it and appreciate it. In this way it lifts you out of your usual preoccupations, it lifts you even beyond your ordinary usual self, into a different kind of world, in which one is concerned with *values* rather than with interests in the economic sense. Unless you are a market gardener, you are not going to be thinking in terms of making money out of the flower. You just value it for its own sake.

OLLE MALLANDER: The more selfless people are, the more possible it becomes to appreciate beauty.

SANGHARAKSHITA: Yes. And the more you appreciate beauty, the more selfless you become. In the book you mentioned I quote Kant to the effect that to appreciate natural beauty is a sign of goodness in man.

But as I say, quite a few people nowadays would not agree that beauty had anything to do with art. It depends, of course, on how you define art. In that book, which I wrote many years ago, I tried to work out my own definition, and this is what I came up with: 'Art is the organization of sensuous impressions into pleasurable formal relations that express the artist's sensibility and communicate to his audience a sense of values that can transform their lives.'

It's as if one goes up step by step in a sort of hierarchy of experience. Art begins with sensuous impressions—impressions of sound, colour, and shape mainly, because art is not concerned with touch, smell, or taste, except in a subordinate sense. And what do we do with these impressions? They are usually chaotic to begin with, so the first thing we do is organize them—and we generally organize them into pleasurable formal relations. To put it simply, we organize them into patterns. However, that is to put it very simply indeed, because then there arises the question of what has been called 'significant form'. It's not just that we bring about these pleasurable formal relations; these relations also have a relation to the artist himself. They express the artist's sensibility—his awareness, his consciousness, of nature, perhaps, or of other people. More than that, they communicate to his (or her) audience a sense of values, a deep underlying philosophy. And they communicate that sense of values in such a way that the lives of that audience are transformed.

So as I see it, any art which is worthy of the name finds itself in a sort of hierarchy. At the lowest level there is art that simply organizes sensuous impressions into pleasurable formal relations. Above this level you can then find art that expresses, through those formal relations, the artist's sensibility. A still higher form of art communicates, through that sensibility, the artist's sense of values. And in the very highest form of art, that sense of values,

communicated in that way, is capable of transforming the lives of the observer, listener, or reader.

OLLE MALLANDER: Could you perhaps mention some names here?

SANGHARAKSHITA: As an example of the lowest level of this hierarchy I think of Moorish tilework of the kind to be seen at the Alhambra. In Islamic art of this period there was a ban on the representation of living things (a ban which was broken by Persian artists) so that what you find in mosques is just lots of very beautiful patterns—in tilework, and calligraphy. And that is, to my way of thinking, the lowest or most basic form of art.

I would say that the Pre-Raphaelites don't go far beyond the first two levels. Yes, there are beautiful patterns, beautiful formal relations which are pleasurable, and yes, a sensibility is expressed, but despite the medievalism, despite the moralism, there is not really much of a deeper communication of values.

In the case of some of the Renaissance artists like Botticelli, or like El Greco, there is an underlying Neoplatonic philosophy, and some communication of values through their work. But to go right to the top of the hierarchy, I would say that in his paintings on the ceiling of the Sistine Chapel Michelangelo definitely expresses a profound philosophy. He was a thinker. He wasn't merely illustrating Bible scenes; those scenes—interspersed with the figures of the sybils and *ignudi* and the prophets—had a significance for him which, I think we may say, transcended their immediate Christian connection. Take, for example, *The Creation of Adam*. It is a familiar, even hackneyed image, nowadays, but it is really an extraordinary interpretation of the old biblical myth. Because the two figures don't make physical contact, it really does seem as if a current of energy is flowing into the comparatively inert and flaccid body of the newly created Adam. It does seem to represent a sort of influx of divine inspiration into humanity. It is, if you like, a symbol of spiritual communication. Michelangelo's art is not just pretty patterns. He is not just expressing his

sensibility, even. He is expressing his vision, his sense of values, and expressing it in such a way as to transform the life of the onlooker.

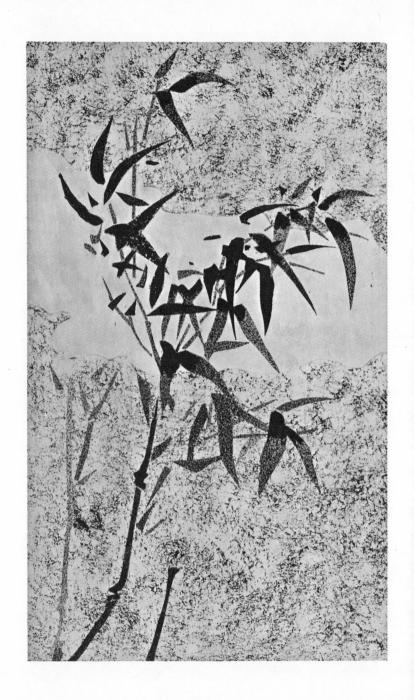

Part Six

THE CONFLICT BETWEEN RELIGION & ART

OLLE MALLANDER: In the first volume of your memoirs you give a hint about there being not one Sangharakshita, but maybe several. Can you elaborate a little on this disclosure?

SANGHARAKSHITA: In *The Thousand-Petalled Lotus* I wrote about the conflict I experienced fairly early on in my Buddhist life between two aspects of myself whom I called 'Sangharakshita I' and 'Sangharakshita II'. Sangharakshita I was the more 'religious-minded', even ascetic, aspect, while Sangharakshita II was the more aesthetic aspect, who was interested in the arts and literature. Sangharakshita I wanted to meditate and realize the truth; Sangharakshita II wanted to experience life....

I was reminded of this recently when someone asked me whether there had been a reconciliation between Sangharakshita I and Sangharakshita II, or whether they were still in conflict. My reply was that it isn't possible for Sangharakshita I to get rid of Sangharakshita II, and it isn't possible for Sangharakshita II to get rid of Sangharakshita I. They have to co-exist. There has to be, it seems, a sort of fruitful tension, or even a fruitful conflict, between the two, as they interact with each other.

OLLE MALLANDER: Is that the creative spur?

55

SANGHARAKSHITA: Yes and no: because if one thinks of creativity in purely aesthetic terms, creativity belongs to Sangharakshita II, not to Sangharakshita I. The tension is not between two types of creativity, but between creativity in the aesthetic sense and something quite different from creativity.

Shortly after he was condemned to death by the Ayatollah Khomeini, Salman Rushdie gave a lecture in which he made the point that there are two absolutes, the religious absolute and the artistic absolute. The religious absolute takes religious values as being absolute: for Islam, Islamic values are absolute, and there can be no compromise. If Salman Rushdie blasphemes against the prophet, as Muslims see it, there can be no compromise: he must just be killed. But Salman Rushdie's attitude is different. He represents the aesthetic absolute, according to which the artist must have complete freedom to express whatever he wishes to express, regardless of any religious or ethical considerations. Here there are two absolutes in conflict, neither prepared to give way to the other. In medieval times, it was the religious absolute which had the power, but in modern times, at least in the West, the aesthetic absolute has the upper hand.

In my own case there is the same kind of conflict—Sangharakshita I representing the religious absolute and Sangharakshita II representing the aesthetic absolute—and it seems that there has to be conflict between them. However, this conflict can be considered in some sense creative, or at least productive—if not in a narrowly aesthetic sense. Because nowadays you cannot really have the religious teacher in the old sense, as representing the religious absolute. Some people in the Buddhist world are not very happy with the way in which I'm doing things, but they have to recognize that the FWBO is successful—which surely has something to do with this 'conflict' of mine.

When I was in Spain two or three years ago, I was invited to speak to a Tibetan group. In discussion with them, I found they were experiencing a great difficulty, which was that according to the Tibetan tradition they were supposed to accept whatever their lama said, without question. In other words, they were up against

the religious absolute. Being good Buddhist disciples they wanted to follow the lama's teaching, but being modern Westerners they could not, in their hearts, accept the religious absolute.

I tend to think that we need a sort of synthesis—for want of a better word—between the two positions. We need a person who is not a lama, who doesn't represent just the religious absolute. And we need a person who does not uphold the aesthetic absolute, who does not break *all* the rules, cross *all* the boundaries. We need a new sort of person.

I think Lama Govinda was a bit like that. He was an artist and at the same time he was something of a mystic. He was an artist and a writer and a poet, as well as being a Buddhist devoted to meditation, Buddhist thought, and Buddhist philosophy. There was nothing absolute about him; he seemed to synthesize the two very well, without any conflict.

The days of the religious absolute are finished. We don't any longer really need teachers—whether they are Christian or Muslim or Buddhist—who stand for a religious absolute. Nor do we need any longer artists, painters, and writers who stand for the aesthetic absolute and refuse to consider moral and spiritual values. It's not that the artist cannot break rules, from the spiritual point of view, but there is no value in breaking rules for the sake of it. Many artists and writers seem to set out with the idea that they can extend the scope of artistic expression just by breaking rules. In my view this is not the case. The aesthetic absolute is no more valid than the religious absolute. The dogmatism of art insists that the rules must be broken, while dogmatic religion insists that the rules must be obeyed, and they are equally dogmatic.

OLLE MALLANDER: What sort of energy nourishes your writing? For instance, you have said about Beethoven that 'at his worst—perhaps at his most characteristic and popular—he is will pretending to be power'. I thought of this as a comment on Western culture in general. Will-power is very much the kind of

energy used by Titans like Picasso. The Eastern artistic attitude seems to be more subtle.

SANGHARAKSHITA: A lot of the characteristically oriental artistic temperament comes from contemplation, and the rapport which develops between the artist and the object of his contemplation. This comes out clearly in Chinese art, especially Chinese landscape art. There is a well-known story of a man who wanted to paint bamboos, and was advised to go and look at bamboos for seven years. So he did. He just looked at bamboos for seven years, before he ever lifted a paintbrush to paint one. What was the point of that? Well, if you contemplate, say, a bamboo, then a sort of empathy springs up between you and it. You have a contact with the bamboo, a feeling for it, and out of that feeling you create. It is as though you and the bamboo come together in a kind of marriage, out of which something is born—a painting of the bamboo, in this case.

OLLE MALLANDER: In Chinese landscape art humanity is very clearly reduced in scale against the vast presence of nature.

SANGHARAKSHITA: This sometimes happens in Western art too. One sometimes has to look very hard to see the human figures in the landscapes of Claude, for instance.

OLLE MALLANDER: How do you find that your meditation practice benefits your own work as a writer?

SANGHARAKSHITA: I find that meditation helps me to write in that it makes my mind calmer and clearer. When I was writing *The Three Jewels*, for example, and came to a point where I wasn't clear, I used to stop and do the meditation of Manjushri, and I used to find that very helpful.

OLLE MALLANDER: The book didn't come from heaven. You had to write it still.

SANGHARAKSHITA: I had to write it still.

OLLE MALLANDER: Do you work from inspiration?

SANGHARAKSHITA: I suppose, yes, it does start with inspiration. An idea just comes into my head—I don't know where it comes from—and then I start thinking. I connect it with other ideas; I connect it with literary material and with Buddhist material. Sometimes I carry all this in my mind for years before I write it down. I usually have several different lines of thought going on in my mind, things I've been thinking about and reflecting on for many years, and eventually, at some suitable opportunity, they get written down. I reflect a lot.

OLLE MALLANDER: What would you say is the nourishing or fuelling energy when you actually start writing?

SANGHARAKSHITA: I think the important thing for me is clarity; I want to make things clear, either to myself or to others.

OLLE MALLANDER: Clarity is very rare nowadays.

SANGHARAKSHITA: Yes. I get a little annoyed when people are confused in their thinking and use words clumsily. I consider this as a sort of intellectual laziness, and perhaps spiritual laziness as well.

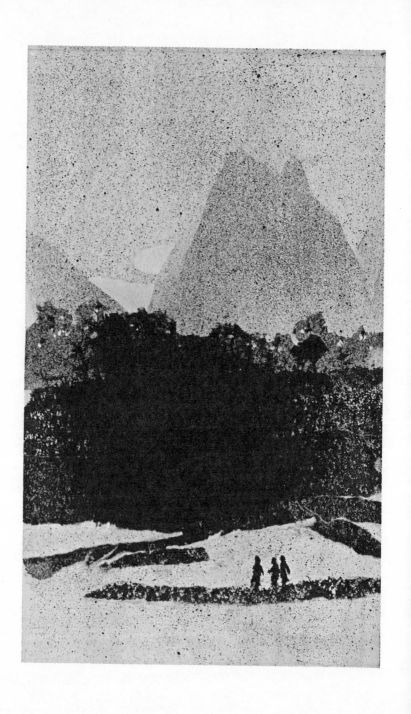

Part Seven

A NEW RENAISSANCE?

OLLE MALLANDER: Many of your books and articles on Buddhism are illustrated by the works of Western artists, particularly from the Renaissance period. What is it in this period do you think that appeals so much to the Buddhist mind?

SANGHARAKSHITA: Often, it is to do not so much with the Buddhist mind as with the designer's mind! But it is certainly true that as far as possible we want to present the message or the teaching of Buddhism through the medium of Western culture. The Renaissance does represent a peak in Western culture, at least as regards painting and architecture, so it is quite natural to take illustrations and images from that particular source. Just recently, for example, I finished a book, and the designer and I came up with the idea of using Botticelli's painting *The Calumny of Apelles* for the cover design. In the book I am replying to criticism and appealing to the truth about the nature of Buddhism, and in the painting there is a female figure pointing upwards, appealing to truth against calumny. Thus it fitted in with the theme of the book quite nicely, though in the event we chose to highlight on the cover a different aspect of the theme of the book.

OLLE MALLANDER: You have written a small pamphlet which perhaps deserves wider circulation. It's called *The Artist's Dream*, and it's a story or parable about an artist who goes through various trials and tribulations and then wakes up to the vision of a new world. Would you say it was something of a self-portrait?

SANGHARAKSHITA: It could be taken as such, although the medium is different, of course. You might say that in my case the artist's dream was the FWBO, because I wrote the story about twenty years ago.

OLLE MALLANDER: You didn't have any particular artist—a visual artist—in mind?

SANGHARAKSHITA: No, I didn't. I deliberately laid the scene in Italy, in the Middle Ages. If I was influenced by anything in writing the story, it was probably by a little-known story of Rossetti's called 'Hand and Soul', written when he was quite young, and which I read many years ago.

OLLE MALLANDER: You have said that it is the colour in paintings to which you respond most directly, and you have mentioned Titian in this regard. But the Renaissance period as a whole seems to be characterized by mastery of colour, compared, for instance, with baroque and rococo painting.

SANGHARAKSHITA: The Venetians were the great colourists, of course, Titian above all. And Tintoretto brings a realistic and dramatic handling of subject-matter to the Venetian tradition. El Greco came under the influence of Tintoretto when he spent some time in Venice, so he can be seen as continuing that tradition, although he has a much more spiritual outlook—a more spiritual philosophy—as well as a much better colour sense than Tintoretto.

OLLE MALLANDER: Would it be fair to say that he is more exalted and in that way more spiritual?

SANGHARAKSHITA: Yes, he is more exalted. He is also more visionary. You could even say of his work that it is sometimes ecstatic; this effect is, of course, very often heightened by the elongated nature of his figures and their upward movement. In El Greco's art there is not so much a uniting of the forces of heaven and earth or hell as a complete escape from the forces of earth. There is an upward soaring to heaven—the sort of movement often associated with Gothic architecture.

OLLE MALLANDER: In the English visionary, William Blake, who I know is very dear to you, we find even more of a sense of the dramatic.

SANGHARAKSHITA: In Blake's work, by contrast with that of El Greco, there is a very definite meeting of the forces of heaven and hell. And here I don't have in mind his famous work, *The Marriage of Heaven and Hell*. What I particularly have in mind is an engraving of his, *The Reunion of the Soul and the Body*, in which a masculine figure is rising up from the ground and a female figure is descending from above, and the two are clasping each other. In Blake's work one gets a strong sense of line, of linear rhythm. Blake isn't much of a colourist, but his line is always vigorous, fluid, and expressive. He took a conscious delight in what he called 'the wiry, bounding line' (by 'bounding' he means, of course, 'boundary-defining').

Art critics have mixed feelings about Blake. He can be very good indeed, but he can also be very bad, and I think most historians of English art would give the highest place not to Blake but to Gainsborough or Turner. Turner captures the dramatic qualities of the elements—mountains, chasms, skies, storms, and sea, and particularly the sea—with perhaps unequalled authority. But to my mind he is at his most interesting when he relates the physically insignificant human being to the much more powerful elements. I'm thinking, for instance, of his *Fire at Sea*, in which a ship has caught fire and human beings are in peril, caught 'between the devil and the deep blue sea'. Turner is very good at

depicting that sort of situation; you are conscious of the physical helplessness of man, confronted by the infinitely more powerful elements by which he is surrounded and almost crushed.

But there is also another side of Turner which I like very much: his classical and mythological, or legendary, paintings. I like his paintings of Rome and Naples, with their southern Italian scenery: blue skies and peaceful landscapes. His paintings of Venice are probably influenced by Canaletto, or can be seen as in some way continuing that tradition. Turner is a many-sided artist, a very great genius indeed. He was a remarkable man, who cared only for his painting. There are some very interesting stories told about him. It is said, for instance, that when he was due to exhibit a painting, he would very often paint the picture at the last moment, actually in the gallery where it was going to be exhibited. He would just arrive, very shabbily dressed, put up his easel, take out his paints, and start to scrabble colours on the canvas. People would think 'What a mess!' and 'What on earth is he doing?', but gradually it would change and develop to become a beautiful picture. He took no notice of anybody. He told Ruskin once that he never bothered to reply to criticism; he just went on in his own way. He refused to have anything to do with fashionable society; he just lived to paint.

Another artist who can be said to have sacrificed his life for art is the Pre-Raphaelite painter Holman Hunt. In his search for authenticity he went all the way to the Dead Sea in order to paint *The Scapegoat*, his famous portrait of a goat which has been, according to ancient and annual Judaic tradition, dedicated to God and then driven out into the wilderness to die 'for the people's sins'. In the first version of the painting Hunt added a rainbow, which is the Biblical symbol of hope (inasmuch as it represented God's promise to Noah that he would not send any more floods upon the earth). But the final version has no rainbow—some say because Hunt had lost hope in the world in the meantime. The symbolism of the painting appeals to me very much, although, perhaps predictably, I was originally attracted to it because of its colours.

OLLE MALLANDER: Blake, Turner, and Hunt are of course all English. What then of the German romantic school? For me, after the greatest Italian masters, Caspar David Friedrich is always there.... He has subtlety and precision, a sense of man in a landscape....

SANGHARAKSHITA: One could say that Friedrich is quintessentially northern. If Titian, for example, is the epitome of the southern artist, filling his works with light and colour, beauty and joy, then Friedrich is very definitely northern: melancholy, capturing not bright sunlight but mist, darkness, and gloom. The qualities of their work are antithetical. When I was last in Germany I visited the art gallery in Düsseldorf, which has a very impressive collection of German romantic paintings. They are generally of this same kind: the product not of beautiful, sunlit Italian landscapes, but of the northern forests and the grey northern skies—melancholy, reflective, mystical. In Friedrich, as in Japanese painting and in Turner, one discovers, as you say, the isolated figure in a huge landscape, the sense of man in relation to his surroundings—in mysterious relation to an unfathomed cosmos.

The work of the German romantic writers also evokes this kind of feeling. I once told Lama Govinda that I had the impression that his writings were influenced by the German romantics (whose work I had got to know in my teens). Lama Govinda said that actually he was not just influenced by these writers; he had certain recollections which led him to believe that he himself was the incarnation of one of them. I later came to understand that he believed that he had been the poet Novalis in a previous lifetime.

It is perhaps not too far-fetched to think that artists are working on a story that takes them many lifetimes to write—even if artists themselves rarely think in these terms. D. H. Lawrence, for example, thought of the novel as a 'thought adventure'. He saw himself not so much as a writer as a preacher; he wanted to communicate certain insights, certain ideas, and he didn't mind spoiling his novels from an artistic point of view if he could do

this. Some people have criticized him for being too much of a preacher, but he would not have regarded that as a criticism; a preacher was what he wanted to be.

OLLE MALLANDER: In a paper you delivered in 1985, *The Glory of the Literary World*, as well as in your book *The Religion of Art*, you have spoken of the possibility of a 'second Renaissance', a Renaissance in which the West would discover the treasury of Eastern art and literature. Does this not seem to have become more and more of a reality as Eastern religious teachers have come to the West in ever-increasing numbers, and with so many more texts being made available in translation?

SANGHARAKSHITA: In my view, this Renaissance has not yet really begun. Many of those who take up some Eastern religion take it up almost as a substitute for Christianity. For instance, in taking up Tibetan Buddhism, some people accept everything the lama says at face value, just as a Christian might accept everything the Bible says, quite literally—or everything the Pope says. There is no real difference. They have found refuge in an authority; they have found a security system, and that is quite a different thing from Enlightenment—or even just knowledge. There seem to be, very broadly, two groups of people, both looking for a security system. Some go back, or try to go back, to the Christian religion: they may go straight back to the traditional view of the Bible as being true both symbolically and literally; or they may decide gently to drop the literal interpretation; but they go back, or part of the way back, to the old security system. Others look for a new security system; but they are looking for the same thing, essentially.

Even though Eastern religions are becoming better known in the West, they are often approached wrongly, and used for wrong purposes. I doubt, therefore, whether there is yet a real Renaissance comparable to the Renaissance that took place in Europe in the fifteenth century as the result of the rediscovery of classical literature, art, and culture. So far, the influx of Eastern teachings

into the West has not produced any great art—nothing outstanding, nothing to compare with the great artistic achievements of the Renaissance.

OLLE MALLANDER: Should we expect it, even?

SANGHARAKSHITA: I don't know if we can expect, but at least we may hope.

OLLE MALLANDER: Don't Buddhists build a better world?

SANGHARAKSHITA: They put up buildings. We ourselves in India are constructing some very big and beautiful buildings, in Poona and other places—more so than we do in Britain, anyway.

OLLE MALLANDER: Are they Buddhist in style?

SANGHARAKSHITA: Yes, one could say that they are in a neo-Buddhist style. We have put up at least four or five buildings of some architectural value, I think. They are designed by a husband and wife team who are both Indian, working with an English architect.

OLLE MALLANDER: The introduction of meditation in the West could surely contribute to a possible cultural rebirth? Meditation is a household word, nowadays.

SANGHARAKSHITA: Indeed. When I returned to England in 1964, meditation was known to only a few people, but now it is an ordinary, everyday thing. If you tell your friends that you meditate, they are not going to be surprised. People are also much more familiar with the idea of vegetarianism; when I was a boy there was only one Indian vegetarian restaurant in London, but now there are hundreds. Hatha yoga too is widely known now, and people who practise it, even if they belong to what we call the

'health and beauty brigade', are usually aware that yoga has some connection with the East.

OLLE MALLANDER: There must be millions of Westerners who have learnt meditation. I could imagine that meditation would help to tune people's sensibilities in such a way as eventually to issue in an artistic renaissance of some kind.

SANGHARAKSHITA: Meditation can certainly be a contributory factor, although by itself it is not enough. You can be a good meditator, but the creative impulse is something quite different. In some ways, you could say, meditation may even inhibit the creative impulse.

On the other hand, if you look at the work of great writers and artists, you can see a sort of spiritual development (to use that expression) taking place. Human beings are rarely completely unified personalities; there are usually a number of personalities fighting for supremacy, now one being uppermost, now another. In the work of Shakespeare, for example, or Dickens, you can see different personalities emerging in a sort of developmental sequence, so that a more and more mature personality emerges, a personality which is more aware of the different sub-personalities, or integrates them more.

OLLE MALLANDER: Then there are, of course, more direct artistic influences from the East—Ravi Shankar for example.

SANGHARAKSHITA: Certainly, there are some Eastern influences already to be discerned in Western art forms. Even the Beatles were influenced to a small degree by Indian classical music. And there is Messaien's *Turangalila Symphony*—Turangalila being the Sanskrit for 'the far-going play'.

OLLE MALLANDER: I would like to ask a general question about the sacredness of art, or the degree of sacredness in art. When does a work of art function on a sacred level? There must always be an

amalgam of many layers, but sometimes one can get a strange feeling of holiness and sacredness.... These are strong words and I rather hesitate to use them; but I suppose what I am talking about is a sense of the sublime.

SANGHARAKSHITA: We must not take the idea of developing 'religious art' too literally. In *The Religion of Art* I distinguish between conventionally religious art and art which is genuinely religious. You can take a picture of a so-called sacred subject, the Madonna and Child for instance (to take an example from Christian art), painted without any real feeling. What you will have is a painting that is religious only by tradition or association, not by virtue of its inner spirit, or the artist's insight and realization. On the other hand, someone with real insight can take the same subject, and make it not only formally but genuinely religious. Then again, you can have a painting that is genuinely religious, in that it is the product of real spiritual insight, but not associated with any specific formally religious imagery—it could be a landscape, or a painting of a flower.

In modern times, maybe since the Renaissance, artistic inspiration has tended to flow less and less in conventionally religious channels. The English critic Middleton Murry said 'When Roman Catholicism died in Britain, then English literature was born.' By this he meant that the spiritual energies which formerly flowed through the church were now free to flow outside it and find expression in secular art and literature. If people today are looking for inspiration—let's say in literary terms, leaving aside the visual arts—unless they are definitely Christian they don't read the Bible, or other formally religious literature. They look to the great poets and novelists. They will get their spiritual nourishment from *those* sources, not from ostensibly religious ones. We have always to distinguish between art which is not genuinely religious in feeling, whether it is formally religious or not, and art which is genuinely religious in feeling, even when it is expressed in secular terms.

The Windhorse symbolizes the energy of the enlightened mind carrying the Three Jewels —the Buddha, the Dharma, and the Sangha—to all sentient beings.

Buddhism is one of the fastest growing spiritual traditions in the Western world. Throughout its 2,500-year history, it has always succeeded in adapting its mode of expression to suit whatever culture it has encountered.

Windhorse Publications aims to continue this tradition as Buddhism comes to the West. Today's Westerners are heirs to the entire Buddhist tradition, free to draw instruction and inspiration from all the many schools and branches. Windhorse publishes works by authors who not only understand the Buddhist tradition but are also familiar with Western culture and the Western mind.

For orders and catalogues contact

WINDHORSE PUBLICATIONS
UNIT 1-316
THE CUSTARD FACTORY
GIBB STREET
BIRMINGHAM B9 4AA
UK

ARYALOKA
HEARTWOOD CIRCLE
NEWMARKET
NEW HAMPSHIRE
NH 03857
USA

Windhorse Publications is an arm of the Friends of the Western Buddhist Order, which has more than forty centres on four continents. Through these centres, members of the Western Buddhist Order offer regular programmes of events for the general public and for more experienced students. These include meditation classes, public talks, study on Buddhist themes and texts, and 'bodywork' classes such as t'ai chi, yoga, and massage. The FWBO also runs several retreat centres and the Karuna Trust, a fundraising charity that supports social welfare projects in the slums and villages of India.

Many FWBO centres have residential spiritual communities and ethical businesses associated with them. Arts activities are encouraged too, as is the development of strong bonds of friendship between people who share the same ideals. In this way the FWBO is developing a unique approach to Buddhism, not simply as a set of techniques, less still as an exotic cultural interest, but as a creatively directed way of life for people living in the modern world.

If you would like more information about the FWBO please write to

LONDON BUDDHIST CENTRE
51 ROMAN ROAD
LONDON
E2 OHU
UK

ARYALOKA
HEARTWOOD CIRCLE
NEWMARKET
NEW HAMPSHIRE
NH 03857
USA